8,75

THE
PLUNDER OF
THE ARTS
IN THE
SEVENTEENTH
CENTURY

THIS IS THE SECOND OF THE
WALTER NEURATH MEMORIAL LECTURES
WHICH WILL BE GIVEN ANNUALLY EACH SPRING ON
SUBJECTS REFLECTING THE INTERESTS OF
THE FOUNDER
OF THAMES AND HUDSON

THE DIRECTORS WISH TO EXPRESS
PARTICULAR GRATITUDE TO THE GOVERNORS AND
MASTER OF BIRKBECK COLLEGE
UNIVERSITY OF LONDON
FOR THEIR GRACIOUS SPONSORSHIP OF
THESE LECTURES

THE
PLUNDER OF
THE ARTS
IN THE
SEVENTEENTH
CENTURY

HUGH TREVOR-ROPER

THAMES AND HUDSON
LONDON

The late Walter Neurath was a publisher who enriched the intellectual world by bringing to his craft not only a remarkable technical understanding but also a wide general culture and an exact knowledge both of living art and of the artistic deposit of history. For this lecture, which commemorates him and his work, I have therefore chosen a subject which, I hope, would have pleased him. I want to touch upon a unique chapter in art-history: a period of history in which the treasures of European art and learning were forcibly and dramatically dislocated and many of them finally fixed in those places in which, without thought of their origin, we look on them today. Today, art and scholarship seem firmly anchored in the museums and institutions to which so many of the books published by Mr Neurath's firm usefully direct us. We regard them as fixtures. But this age of stability, of petrification, was preceded by an age of volcanic convulsion; and that convulsion, which is the subject of my lecture, is to be explained, at least in part, by the larger function which art and learning possessed in the past – and may yet possess again.

5

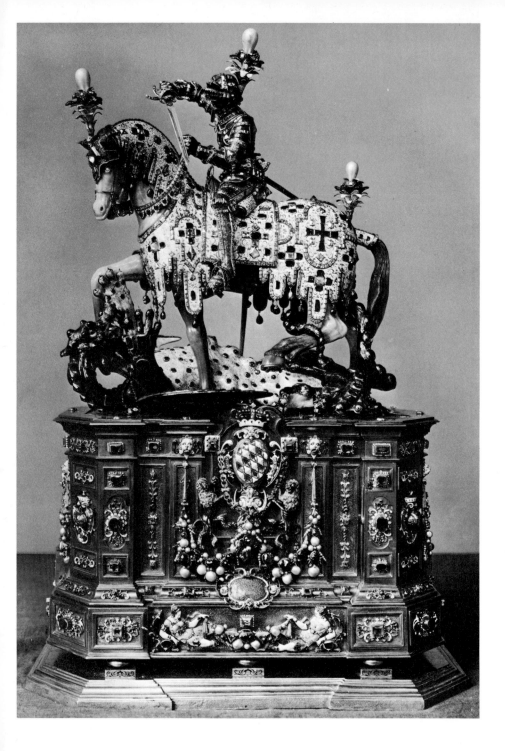

ART HAS MANY FUNCTIONS, social as well as individual. It has
one function for the artist, another for the patron. To the artist and the
aesthete it expresses a Platonic conception of beauty or a personal
conviction; to the patron it may represent this, but it also represents other
things: propaganda, pride, prestige. To the city state of ancient Greece
or medieval Italy it illustrated the independence of the republic,
the *virtù* of its citizens; to the Renaissance monarchy it illustrated the
continuity and strength of the dynasty, the personal magnificence of the
prince; and age after age, the Church, the greatest of all patrons, made
it yet another instrument to capture, elevate, even hypnotize the devout
mind. These are truisms which there is no need to emphasize. Without
these 'second causes' of art, art itself would be very different – and there
would be much less of it.

Every weapon of propaganda inevitably provokes opposition. If art,
at times, is an instrument to enslave men's minds, heretics who wish
to set them free will find themselves also enemies of art – or at least of
that art. Like the Iconoclasts of eighth-century Byzantium, or the
Puritans of Reformation Europe, they will seek to destroy this aesthetic
arm of the enemy; or at least, like modern Communists in Russia or
China, they will try to neutralize, to sterilize it, by separating it from its
living context. Equally, if art gives an aura of prestige to a city or a
dynasty, rival cities or dynasties, which set out to conquer and humble
them, will seek also to destroy their 'myth' by depriving them of this
aura and appropriating it to themselves, like cannibals who, by
devouring parts of their enemies, think thereby to acquire their *mana*,
the intangible source of their strength. At least they will do this in
certain periods of history: in times, particularly, of ideological struggle,
when wars are fought not for limited objectives, between temporary

7

*1 A bejewelled St George, made for the dukes of Bavaria about 1590, shows one of the
functions of Renaissance art-collecting – a form of propaganda combining artistic taste with
ostentatious wealth.*

enemies respectful of each other's basic rights and independent authority, but totally, to destroy altogether hated systems of government, to break and subject independent powers, to create a New Order.

Such periods are vivid in our minds. The recently published memoirs of Albert Speer describe Hitler's resolve to convert Berlin into the capital of conquered Europe and to deck that capital with the artistic loot of Europe. A century and a half before, Napoleon had sought to do the same for the benefit of Paris. The process has been described in fascinating detail by Mr Cecil Gould.[1] But these attempts both failed: the victors of 1815, as of 1945, insisted on the restoration of the artistic, as of the political, *status quo ante*. To find an effective dislocation of art on a comparable scale, we must look farther back in history. The subject with which I am concerned is the last unredressed violent artistic upheaval in Europe: the upheaval which coincided with the great ideological convulsion of the Thirty Years' War.

It is a particularly dramatic upheaval, for several reasons. First, all the conditions of aesthetic cannibalism, which I have mentioned, were present. The struggles of Protestants and Catholics were holy wars, wars of annihilation. The Habsburgs sought not merely to restore their political empire in northern Europe and in Germany but also to stamp out Protestantism and to eliminate Protestant principalities; and their great adversary, Gustavus Adolphus, king of Sweden, when he swooped down from the Baltic to the Danube, as the lion of the north, the avenging angel foreshadowed in the books of Daniel and the Apocalypse, was no less ambitious

to cast the kingdoms old
into another mould.

In England, in those same years, a political struggle led rapidly to a social, ideological revolution. The monarchy was overthrown, the king publicly executed, and a new experiment, both social and political, was defended by an unexampled military dictatorship. Secondly, the European princes, at that time, were princes of a special kind. They were not just secular kings. They were princes by divine right, priest-kings who combined religious with secular power; and

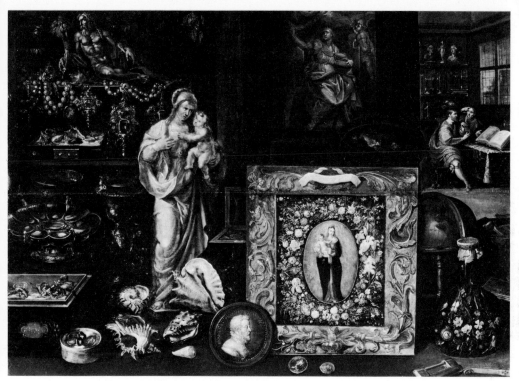

2 *The Renaissance 'Kunstkammer' reflected a wide variety of interest: from natural curios like shells and fossils to antique bronzes, contemporary paintings, and sculpture.*

they illustrated this double power by an ostentatious courtly culture which combined the pagan magnificence of the Renaissance with the learned or artistic propaganda of their Church.

What a subject they provide, the collector-princes of Renaissance Europe.[2] We can trace their history from the fifteenth-century Valois dukes of Burgundy, those incomparable patrons, who drew the artists of Europe to Dijon and Flanders, or from the usurping princes of Italy who stole the aesthetic *mana* of the old Italian communes and secularized it for their own dynastic glory. In the next century, the Burgundian tradition was carried by heredity into the house of Habsburg and transferred to Spain, while in France the rival house of Valois, cut off from Burgundy, refreshed itself from conquered Italy. Intermarriage,

family competition, mere fashion soon did the rest. To be philistine, not to patronize or collect, merely (like some German princes) to gorge and hunt, was an undignified rusticity, unworthy of royalty. By 1600, 'the taste of angels'[3] had become general throughout Europe.

Of course the taste was not entirely new. Its rudiments were there, even in the dullest northern courts. Every prince had always had his treasure, his *Kunstkammer*, his jewels and dynastic portraits; these were part of the ordinary apparatus of royalty, like the crown and sceptre, the unction and the thaumaturgical power. But now this was not enough. Around this elementary nucleus had been built a rich, elaborate crust of secular magnificence. Now, if he were to be in the fashion, a prince must be a Maecenas: he must be a patron of art and learning. He must have great galleries and great libraries. And from the mid-sixteenth century, with the Reformation and Counter-Reformation, when princes, Protestant and Catholic alike, became the defenders, almost the proprietors of the Church in their dominions, their galleries and libraries acquired a spiritual character too. There was Caesaro-papism in the arts no less than in politics, as the princely patrons of the Church set out to dazzle their subjects and eclipse their rivals by their theological learning and iconographical magnificence.

What began as a royal monopoly soon became an aristocratic fashion. By the end of the sixteenth century, when the hierarchical form of society had been positively accentuated throughout Europe, the aristocracy everywhere had sought to follow the royal example. Spanish grandees and Bohemian magnates imitated, in their petty courts, the cultural fashions set by Philip II and Rudolf II. Great ministers like Cardinal Granvelle, great financiers like Ulrich von Fugger, would eclipse even princes by their collections of pictures and tapestries, books and bindings, manuscripts and miniatures. And in the next century, at the courts of that greatest of royal aesthetes, Charles I of England, and that greatest of royal culture-vultures, Queen Christina of Sweden, illiterate parvenus like the first duke of Buckingham and Count Magnus de la Gardie, having begun by following the fashion, would end as discriminating collectors and patrons of art.

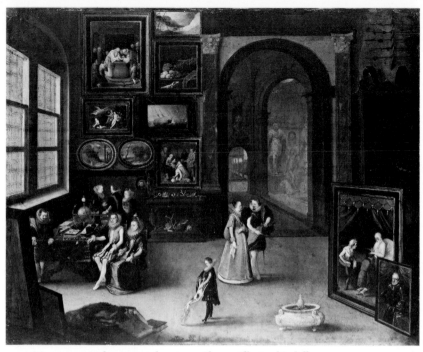

3, 4 Art patronage in the seventeenth century. Above: Albert and Isabella, rulers of the Spanish Netherlands, visit Rubens in his studio in Antwerp. Below: a new curio cabinet ('Kunstschrank'), the result of five years' work by Augsburg craftsmen, is delivered to Philip II, duke of Pomerania in 1617.

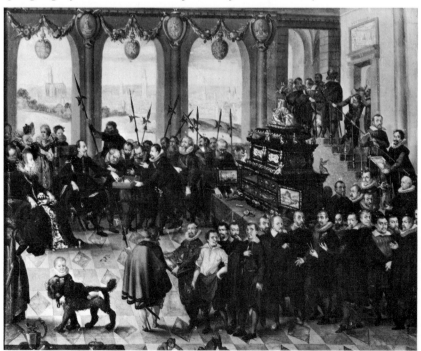

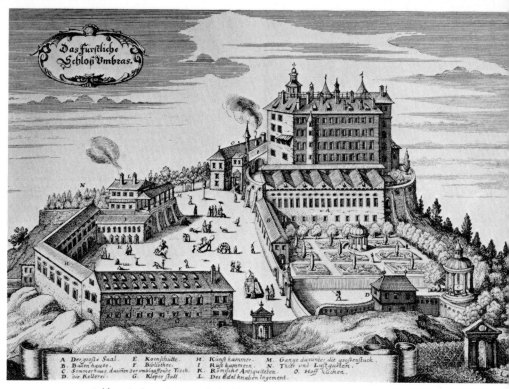

5 Schloss Ambras, Austria. The building on the left was Archduke Ferdinand's 'Kunstkammer'.

Much of it, of course, was mere fashion: a social or a political necessity. But among these royal and aristocratic collectors there were some who, like Charles I of England, had a genuine love of art and a fine or original taste in it. Philip II of Spain, for instance, that cold bigot of the Escorial, whose inflexible Catholicism nevertheless rested on twisted pillars (his most intimate intellectual advisers – his librarian, his geographer, and his printer – were all secret heretics) was a passionate aesthete, with a particular taste for the tortured fantasies of Hieronymus Bosch.[4] Philip's cousin, the Archduke Ferdinand, the first systematic collector among the Austrian Habsburgs, turned his Tyrolean palace of Ambras into a museum of all the arts. And then there was Ferdinand's nephew, that melancholy neurotic hermit, the greatest of all collectors,

the Emperor Rudolf II. Isolated in his palace at Prague, inaccessible to his ministers of state, and only rarely to be spotted by strangers as he wandered, disguised as a groom, through his stables or menageries, that most eccentric of all the Habsburgs built up around himself, as a bizarre protective shell, the richest and most fascinating collection in Europe. To enjoy his patronage there came from all Europe painters and sculptors, tapestry-makers, clockmakers and astrologers; the emperor himself painted and carved, wove tapestries and made clocks among them; and the Leonardos and Titians, Raphaels and Dürers which he bought were joined in the Hradčany Palace by the new works which were specially painted for his own ambiguous tastes: the zoological fantasies of Brueghel and Roelant de Savery, the mannerist *bravura* of Giambologna, the animated and mechanized vegetables of Arcimboldi.[5]

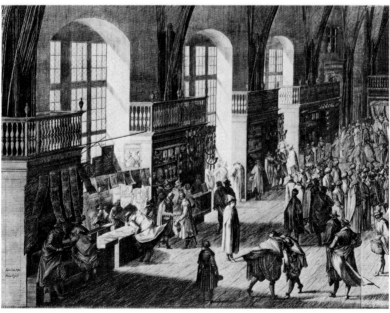

6 The Wenceslas Hall of the Hradčany Palace in Prague in the time of Rudolf II.

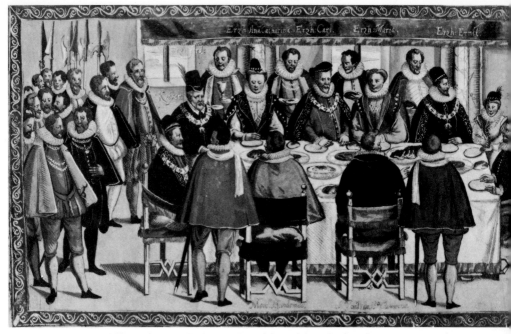

7 *Rudolf II at dinner with other members of the Habsburg family. The emperor sits on the left. Next to him is his uncle, the Archduke Ferdinand, owner of Schloss Ambras.*

Such lavish purchases and cut-throat competition among princes naturally bred opposition among those who ultimately paid for their extravagance, their subjects; and as the zeal of the collectors was merged in ideological orthodoxy, so the economic indignation of the taxpayers was gradually fortified by religious heresy. Armed by this double rage, Protestant iconoclasts, in the sixteenth century, had smashed the seductive treasures of the established Church. At the end of that century the princes, as heirs to the Church, began to incur the same hostility. The Bavarian estates, in particular, grumbled at the heedless expenditure of their Wittelsbach dukes. The Bavarian nobility had but recently been weaned from Protestantism and they did not relish the sight of the flamboyant new Jesuit churches, the cost of whose splendid decoration and elaborate music fell ultimately upon them. They demanded the reduction of Albert V's proliferating choirboys and

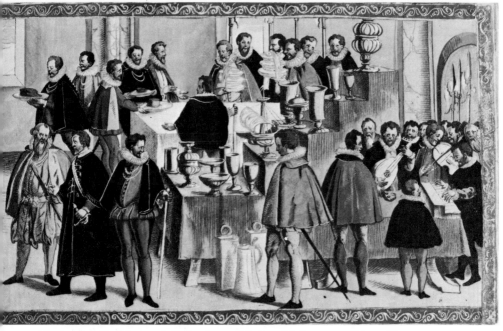

On the other side of the room is displayed some of the imperial plate – cups, dishes, goblets, and a centrepiece in the shape of a ship. On the right the emperor's orchestra plays.

William V's 'corrupt collection of strange and useless things' – that is, pictures, organs, *objets d'art*.[6] But in general this opposition was held firmly down; and after 1598, when peace gradually restored prosperity to all Europe, the competition quickened as never before. Those were the years when the European art-market was first organized to supply a whole continent; and it was a continent at peace – the peace of Philip III and James I and Rudolf II and 'the Archdukes': an ever-expanding peace of opulence, extravagance and display.

This new international art-market was organized, above all, in Flanders – i.e. the Spanish Netherlands, now Belgium – and, particularly, in the old economic capital of the Netherlands, Antwerp. Italy was still a storehouse to be ransacked by Spanish governors, French and English ambassadors, but already by the 1560s the centre of new production had moved north, to the Netherlands. As Cardinal

Granvelle wrote from Rome in 1568, '*nous n'avons icy les painctres à la main comme au Pays d'Embas*': Michelangelo was dead and Titian '*fort caducque*'; and he recommended the Netherlands, from which he himself had just been driven by the mutinous Burgundian nobility, as the best hunting-ground for new talent. And the Netherlands rose to the economic as well as to the artistic opportunities of the time. There the manufacture of works of art was a highly organized industry, their sale a closely guarded monopoly. It was in Flanders that the great foreign buyers placed their commissions, in Flanders that old masters were sold (and faked) on a large scale, from Flanders that the new artists set out to make their fortunes at the courts of London, Paris, Prague, Madrid. The ruler of Flanders, the Archduke Albert, brother of the Emperor Rudolf, was himself a great patron and consumer of the national industry; and the greatest of all the painters of his time was a Fleming: Peter Paul Rubens, whose busy workshop filled the devastated churches of Flanders, repaired the damage wrought by iconoclasm, Calvinism and war, and supplied the great propagandist paintings of the courts of Europe: the triumphs of Henri IV and Marie de Médicis for the Palais Luxembourg at Paris, the apotheosis of King James for the Banqueting Hall of Whitehall in London.[7]

So far, so good: in those years of swelling peace the mechanism of the market functioned. Supply then kept up with demand, communications were easy, princes had (or thought that they had) money to spend, and ideological passions were still or stifled. But soon that happy state was to end. In retrospect we can see that the twenty years from 1598 to 1618, those years of general peace, the extravagant, magnificent years of Philip III and Lerma, of Henri IV and Marie de Médicis, of James I and the Archdukes, of Rudolf II and Maximilian I of Bavaria, were an Indian summer, the last years of the Christian princes of the Renaissance, and their bizarre, exotic, competitive courts. In the next thirty years that elaborate, Ptolemaic system would go down in revolution and civil war, and the smooth working of the international art-market would be quickened and distorted by a new force: the pressure of puritan iconoclasm and the piracy of the great art-gangsters.

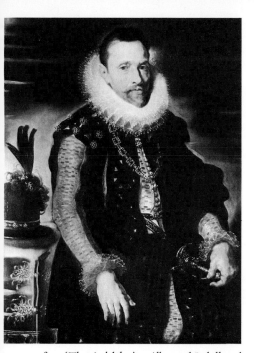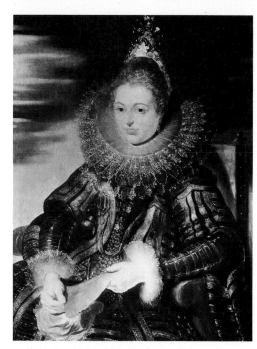

8, 9 'The Archdukes' – Albert and Isabella, who governed the Spanish Netherlands after the death of Isabella's father Philip II in 1598. Portraits by Rubens.

The Thirty Years' War, that last, most convulsive phase of the ideological wars of the Reformation, began (as we now reckon) in Prague when the princely figurehead of international Calvinism, Frederick V, Elector Palatine, was suddenly declared, by a revolu- tionary Protestant assembly, king of Bohemia. Prague had been the capital of Rudolf II who had assembled there the common treasury of the house of Austria. Since Rudolf's death in 1612, some of his collections had been taken to Vienna; but the great bulk remained in what seemed, in those days of Turkish wars, the safer capital of Prague. Now they were threatened not by foreign war but by revolution at home. In August 1619 the rebellious Bohemian nobility, having deposed the Habsburgs (at least on paper), proposed to convert their treasure into cash in order to finance their revolution. There was a silver fountain, they pointed out, worth a fortune, with which the Prince of Liechten- stein had bought his princely title: the Jamnitzer fountain, now in

17

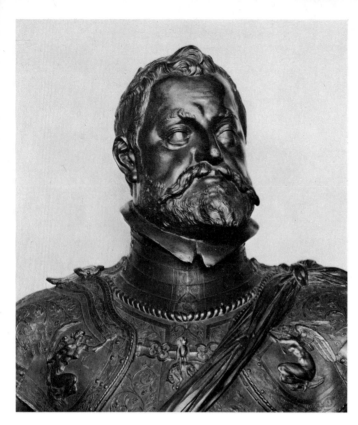

10 *The Emperor Rudolf II by Adriaen de Vries, a Dutch artist who settled in the imperial capital of Prague.*

Vienna. There were all those silver writing-tables, clocks, etc., in which the late emperor had delighted. There were also 'statues and paintings, many of them shameless representations of naked bodies, apter to corrupt than to enlighten men's minds'. All these, the rebels suggested, should be appraised by artists and then pawned to the merchants of Nuremberg.... So, already we see that mixture of ideological puritanism with the economic needs of revolution which would achieve its great triumph in England in 1649. We should not forget that Prague, in that brief period 1618–20, was the holy city, the centre of the messianic puritanism of Europe. But this time the act was not completed. The inventory of Rudolf's collection was compiled; but the battle of the White Mountain forestalled the sale; and if any of the treasure was lost, it was paid to its Bavarian rescuers, not sacrificed to ideological zeal.[8]

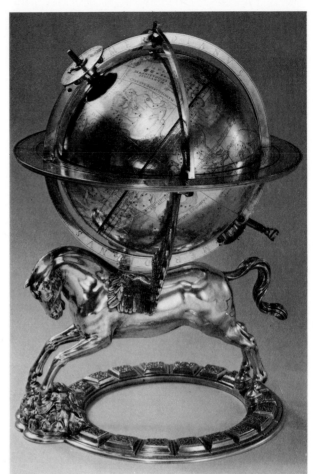

11, 12 *Two of Rudolf's treasures. Above: a celestial globe on the back of Pegasus, made in 1579 by Gerhard Emmoser; this was one of the objects looted by Queen Christina in 1648. Left: a late sixteenth-century credence vessel of silver and sharks' teeth.*

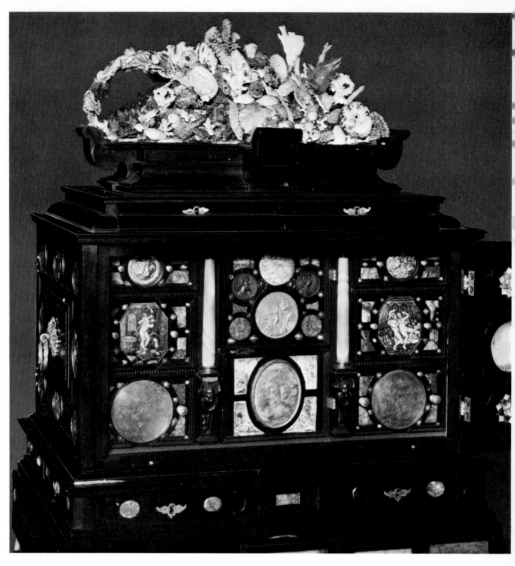

13 Rudolf II's 'Kunstschrank'. The door is open, revealing a series of smaller doors and drawers, inlaid with semi-precious stone, medals, intaglios, and faience panels. On the top is a composition of shells and geological specimens.

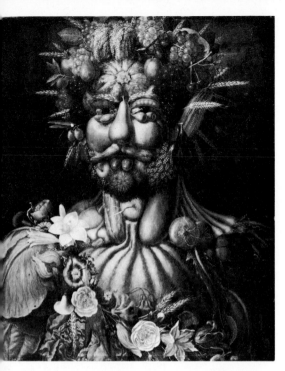

14, 15 *Further items in Rudolf's collection. Left: a 'vegetable' portrait by Arcimboldi, possibly Rudolf himself. Bottom left: detail from Brueghel's 'Dulle Griet'. Both pictures were looted by the Swedes in 1648.*

16 *Among Rudolf's relatively few antique marbles was this torso of a young man, known as 'Ilioneus', one of Niobe's sons.*

21

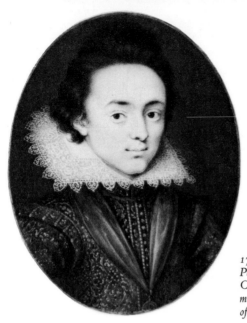

17 Frederick V, Elector Palatine, a miniature by Isaac Oliver painted at the time of his marriage to Princess Elizabeth of England in 1613.

The first cultural victim of the Thirty Years' War was not the Habsburg treasure of Prague but that of its infelicitous usurper, the Elector Palatine.

For the battle of the White Mountain near Prague, which ended the independence and the Protestantism of Bohemia, was soon followed by an even more spectacular disaster to European Protestantism: the invasion of the Palatine by Spinola in 1620, the storming of Heidelberg by Tilly in 1622, the dispossession and flight of the rash prince who had dared to disturb the balance of power in Germany. This second disaster exposed to pillage a treasure as great, in the eyes of Protestants, as Rudolf's *Kunstkammer* could be to the house of Habsburg: the great library of the princes Palatine in Heidelberg. For if Catholic princes gloried in their picture-galleries, good Calvinist princes, who distrusted such pagan or popish imagery, gloried above all in their libraries; and all such libraries, in the early seventeenth century, were eclipsed by the glory of Protestant learning, the *Palatina*.

The Palatine Library had been founded in the fifteenth century. In the next century it had been fostered by a succession of humanist princes, and enriched by the spoils of German monasteries. But its greatest period began in 1602 with the appointment, as librarian, of the

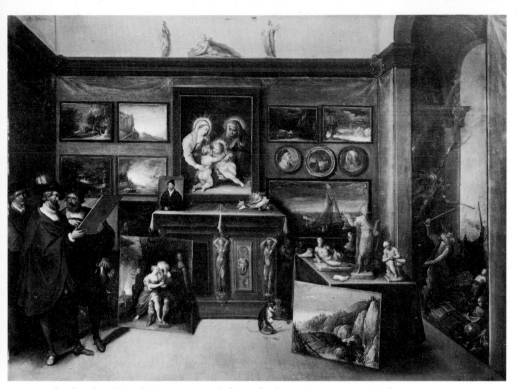

18 The Thirty Years' War was a period of crisis for the arts. Patrons were ruined, treasuries plundered, collections dispersed. In this allegory by Frans Francken connoisseurs examine a painting, but outside creatures with asses' heads stand for Philistinism and stupidity.

famous Dutch scholar Jan Gruytere, known to the learned as Janus Gruter.[9] Unfortunately, in those very years of peace in which Gruter was nursing this great Protestant library, another famous scholar, Cardinal Baronius, was giving similar attention to the papal library in Rome. It was on the advice of Baronius that the Vatican Library was at last stabilized, and its manuscripts catalogued; and this process was completed in 1620, the very year of the battle of the White Mountain.[10] When that great victory for the Church had been followed by the capture of the usurper's own capital, what more natural than that the pope should signalize his triumph by cannibalizing his most dangerous enemy: by absorbing his intellectual sustenance, his *mana*; by swallowing up the *Palatina* in the *Vaticana*?

23

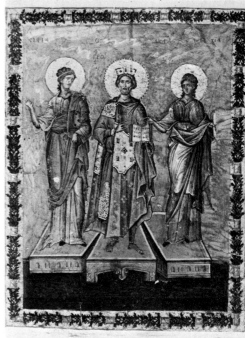

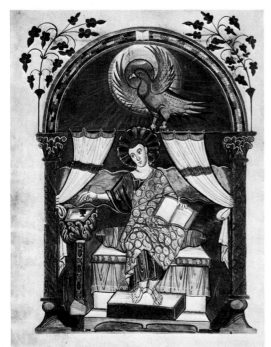

19–22 *After Frederick's defeat in the battle of
the White Mountain in 1620, his own capital of
Heidelberg was attacked and pillaged and its
famous library presented by the duke of Bavaria
to the Pope. This page shows three of its
treasures, which remain in the Vatican Library.*

*Above left: page from a fifteenth-century
manuscript of Virgil's Eclogues.*
*Above right: page from a twelfth- or thirteenth-
century Psalter, showing David between
Wisdom and Prophecy.*

*Left and opposite: page showing St John the
Evangelist and the ivory book-cover of the
Lorsch Gospels, one of the masterpieces of
Carolingian art.*

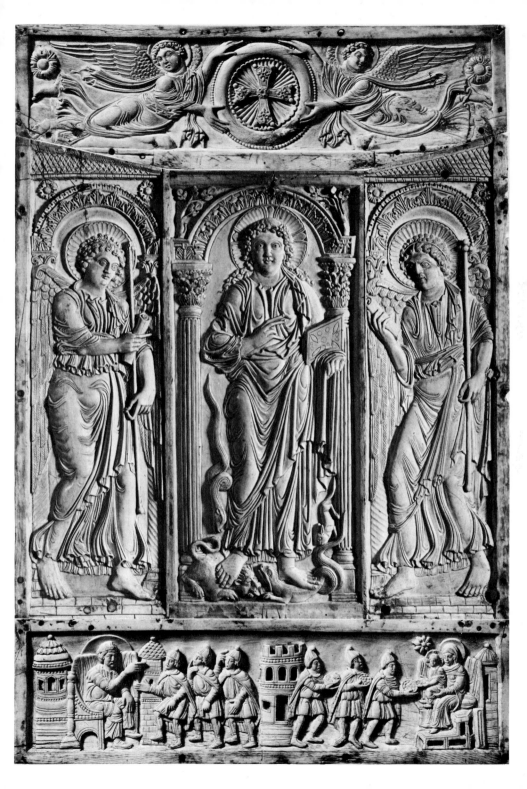

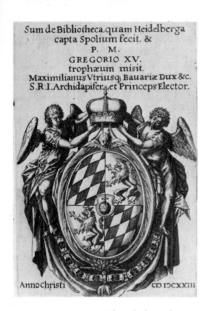

23 Book-plate inserted in the looted books of the Palatine Library. The translation reads: 'I am from the Library which, after the capture of Heidelberg, Maximilian, Duke of Bavaria . . ., took as spoil and sent as a trophy to Pope Gregory XV.' This particular example is from one of the books returned by Pius VI in 1815.

The duke of Bavaria, the victorious generalissimo of the Habsburgs and the Counter-Reformation, duly made the offer, and Pope Gregory XV eagerly grasped it. In 1622 he sent to Heidelberg Leo Allatius, a learned Greek, a bigot of the Uniate Church, who was already employed as an archivist in the Vatican Library.[11] The unfortunate Gruter, who had fled for safety to Tübingen, learned of the ruin of his work as the busy Greek seized the entire collection of manuscripts and the best of the printed books. Gruter's own personal library, together with that of the university and the *collegium sapientiae*, was thrown into the general stock. In order to reduce the weight, the bindings and wrappers were removed, and with them the evidence of former ownership. In vain the people of Heidelberg obstructed the act of spoliation: Tilly ordered his troops to support Allatius; borrowed books were traced and forcibly recovered; and in February 1623 a long train of mules, each wearing round its neck a silver label with the inscription *fero bibliothecam Principis Palatini*, set out from Heidelberg to carry up the Rhine and over the Alpine passes into Italy the 196 cases in which were packed the stripped relics of the greatest of German libraries. It was not till 1624 that the slow mule-train arrived in Rome, to deliver its burden to the new pope, Urban VIII. Except for a few

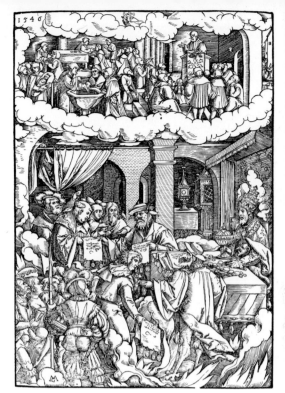

24 *Another looted Palatine book, restored in the nineteenth century, was a German translation of Sebastian Meyer's 'Commentary on the Apocalypse' (Zurich 1544) made for the Prince Palatine Ottheinrich (1502–59). This woodcut shows the Pope, surrounded by devils, trafficking in indulgences. In the clouds above, by contrast, is a purified Protestant service.*

manuscripts of purely German interest reluctantly disgorged by Pius VI to the king of Prussia in 1815, they are still there.

The deliberate plunder of the Palatine Library was an act of robbery unexampled in the previous wars of the European nations – although not of the Italian princes. But the example, once given, was soon followed. The Thirty Years' War was to see a progressive deterioration in the laws and conventions of war; and the process was quickened by the competitive greed of the princes and their ministers, by the collectors' gluttony which characterized the age of Richelieu and Mazarin, Philip IV and Charles I. A few years after the seizure of the Palatine Library, that quickened process was illustrated by the greatest national sale until the tragedy of Charles I. In form, it was a peaceful sale; but the shock which it sent through Europe, and its intimate connection with that tragedy, causes it to fit into the pattern of plunder. I refer to the dispersal, in 1627–30, of the Mantuan collection.[12]

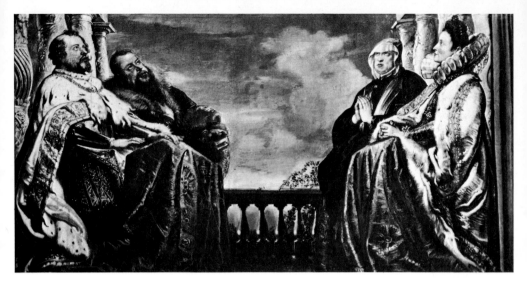

The collection of the Gonzaga, dukes of Mantua, had been famous for over a century. It had been built up by patronage and plunder: the patronage which successive dukes had extended to the great Italian masters – to Mantegna, Leonardo, Perugino and Correggio – and the plunder of Urbino by Cesare Borgia in 1502. All through the sixteenth century the dukes of Mantua prospered and their palaces were enlarged and decorated to advertise their prosperity. At Mantua Giulio Romano worked in the 1520s and 1530s; there Rubens studied in the 1590s. By 1600 the citizens of Mantua gloried in what seemed to them not a private collection of the duke but a national gallery, the possession of their city. They were soon to be reminded, forcibly, that this was not so.

The trouble was that Mantua, like all the industrial cities of North Italy, was in economic difficulties. From 1612, the silk industry, the basis of its prosperity, was in crisis and the dukes could no longer keep up their lavish court out of a dwindling income. They were reduced to pawning their jewellery. In due course they had to choose whether to lose their jewels or to redeem them by selling something else.

Of course, if the dukes of Mantua had been like the dukes of Bavaria – or indeed any other princes of Europe – they would not have sold their treasures. Those treasures, to any self-respecting Renaissance prince, were the symbol of his strength. They would have sold something else –

28

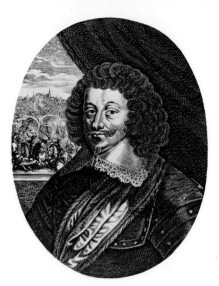

offices, titles of honour, anything – or imposed new taxes, or just let the debts mount. Unfortunately, the two dukes of Mantua who reigned from 1612 to 1627 were not self-respecting princes: they were disreputable ex-cardinals whose ruling passion was not for works of art but for mistresses, relics, food and drink, and, above all, dwarfs and parrots. This being so, their subjects, in those years of financial stringency, reasonably began to tremble for those pictures – *their* pictures – which had made their city one of the artistic wonders of the world.

Already in 1623, the year when the Palatine Library was being transported to Rome, the duke of Mantua dropped the first hint. He dropped it to the countess of Arundel – the wife of that greatest of English noble *virtuosi* – and to the painter Antony van Dyck, both of whom happened to be staying at his court. The hint soon bore fruit. Three years later, a strange, cosmopolitan figure, of uncertain nationality, arrived in Mantua from Venice for secret conversations with the ducal grand chancellor. The name of this visitor was Daniel Nys, and he called himself a merchant: he supplied the court of Mantua with mirrors, perfumes, vases, furs and other bric-à-brac; but he also had another, more significant function: he was the secret artistic agent of Charles I, and also of the earl of Arundel and the duke of Buckingham. Soon afterwards, Nys was joined by Nicolas Lanier, the Master of the

29

27, 28 Engraved copies of two of Titian's 'Twelve Caesars' (Nero and Titus), bought by Charles I from the duke of Mantua in 1627. The originals have been lost.

King's Music, who stayed in his house and acted under his direction. Together, these two negotiated, in close secrecy, for the sale of the collection to Charles I.

Of course the facts leaked out and at once there were protests. The ex-treasurer of the court, Niccolò Avellani, solemnly warned the duke that 'if it is true that these pictures are to be sold, being such that the whole world has not the like, all friends of the house of Mantua will grieve'. But the only response to this protest was still greater secrecy at court. Then, in August 1627, the deal was clinched. Nys bought the bulk of the pictures, including Titian's *Twelve Caesars*, Raphael's *Holy Family* ('for which the duke of Mantua gave a marquisate worth 50,000 scudi and the late grand duke of Florence would have given the duke of Mantua 25,000 *ducatoni* in ready money'), a work of Andrea del Sarto, two of Correggio, one of Caravaggio, and many others. For all these he undertook to pay £15,000.

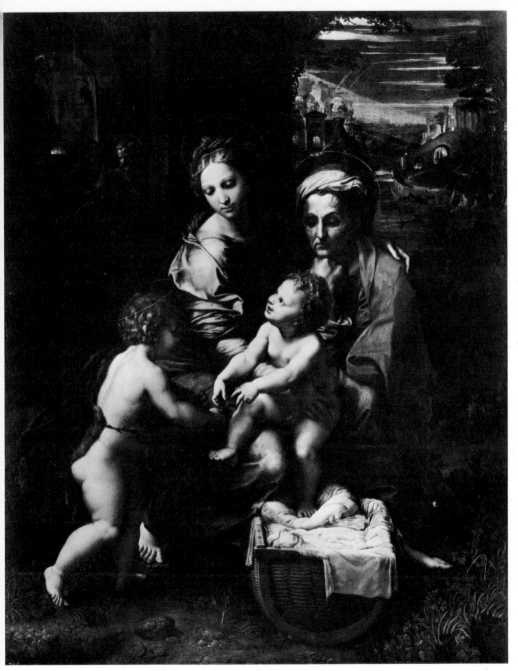

29 Raphael's 'Holy Family' (known as 'La Perla'), bought by Charles I from the
Gonzaga and later acquired by Philip IV of Spain.

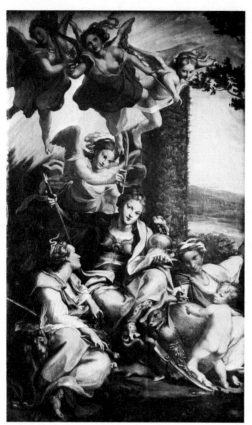
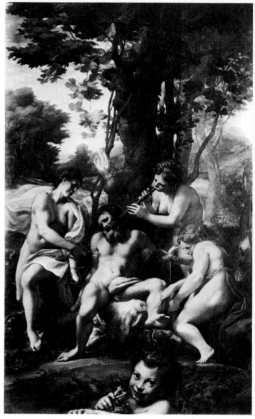

When the news of this sale broke, there was a terrible outcry in Mantua. The duke was so alarmed by it that he even, for a moment, talked of raising a loan and buying back his pictures. But just at that moment he learned that a particularly desirable she-dwarf had come on to the market in Hungary, and that decided him. Subsiding in his villa at Maderno, he solaced himself with perfumes obligingly sold to him by that universal purveyor Daniel Nys. 'What is done is done,' exclaimed the ex-treasurer Avellani, 'but God pardon whoever proposed such a sale.' Nys, of course, was jubilant. Of all his deals, he said, this had been the most difficult: 'I myself am astounded at my success.' He added that the city of Mantua and all the princes of Christendom were astonished that the duke should have parted with

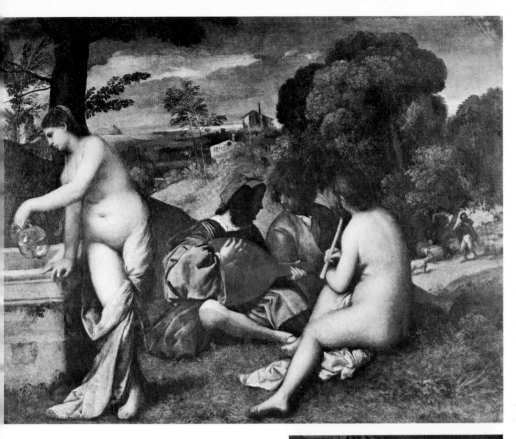

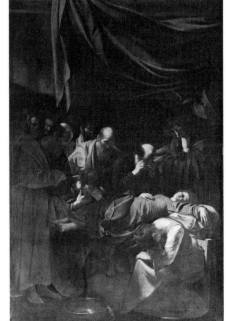

30–33 *Four of Charles I's Mantuan pictures. Bought after his death by Jabach or Mazarin, they all came eventually into Louis XIV's possession and so into the Louvre.*

Opposite: Correggio's 'Virtue' and 'Vice', companion paintings for an apartment in the palace of Mantua.
Above: Giorgione's 'Pastoral Concert'.
Right: Caravaggio's 'Death of the Virgin'.

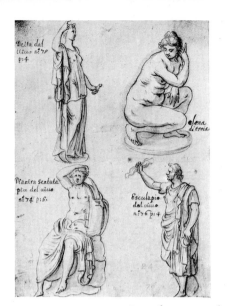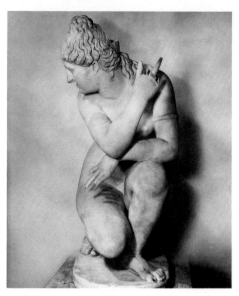

34, 35 A page from a pictorial inventory of the statues acquired by Charles I from Mantua, featuring the Crouching Venus (right), then described as 'Helen of Troy'.

his pictures, 'and the people of Mantua set up such a cry that if the duke had been able to get them back, he would gladly have paid twice the sum, and his people would have found it for him'. It was particularly gratifying to Nys that Charles had pipped the emperor and the grand duke of Tuscany to the post. The collection was 'so wonderful and glorious that the like will never again be met with; they are truly worthy of so great a king as His Majesty ... In this business I have been aided by divine assistance ... To God then be the glory!'

Nor was this the limit of Nys's success. Within a year he was telling the king that there were still more treasures in Mantua. The duke had reserved from the sale 'nine great pictures', the pick of the whole collection, Mantegna's *Triumphs of Julius Caesar*, '*cosa rara e unica al mondo*': 'he who does not have them has nothing' – and, moreover, Cardinal Richelieu was after them. And then there were statues, including sleeping Cupids said to be by Praxiteles and Michelangelo, 'and believe me, all the statues in England are bagatelles compared with these'. There was danger of losing all these, since they were much coveted by the queen mother of France and the grand duke of Tuscany.

34

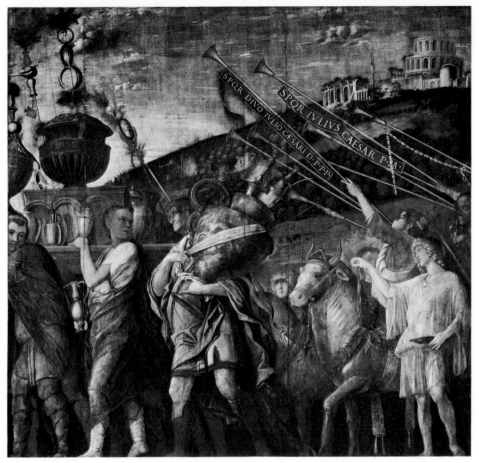

36 One of Mantegna's series 'The Triumphs of Julius Caesar': among the few important Mantuan paintings acquired by Charles I that were not sold by the Commonwealth.

However, in the end all was well. Once again the king of England got in first: he bought the lot for just over £10,000.

The purchase of the Mantua collection was regarded by Charles I as the greatest triumph of his generally unsuccessful reign. Contemporaries regarded the sale as a European scandal. Rubens protested that the duke of Mantua should have died rather than allow it. But in fact the world probably gained rather than lost by it. For barely had the ducal

treasures arrived in England when the Thirty Years' War came to Mantua. In 1630 imperial troops captured and sacked the city and all the remaining contents of the ducal palaces simply disappeared. In vain the empress, herself a Gonzaga princess, implored her husband to secure the return at least of the most precious treasures. Nothing was ever recovered. Eight years before, in 1622, at her marriage to the emperor, which had been celebrated in Mantua, all the treasures of the house of Gonzaga had been displayed there to honour 'the greatest princess in the world' and to dazzle the royal and princely wedding-guests. Now all had gone; the palaces were stripped bare. The best of the treasures were safer – for the time being – in England.

It is worth remarking, as an illustration of the intermixture of art and politics, and as a sidelight on the priorities of King Charles I, how he paid for his great triumph. At the very time of the sale, he was sending an expedition, under the duke of Buckingham, to the Isle of Ré, to relieve the Huguenot citadel of La Rochelle, hard pressed by the army of Cardinal Richelieu. The financing of this expedition, as of all Charles I's operations, was handled by his regular international financier, Sir Philip Burlamachi. But just as the expedition was about to sail, Burlamachi received the bill for the Mantuan pictures. He was aghast. 'I pray you,' he wrote to the king's secretary, 'let me know His Majesty's pleasure, but above all where money shall be found to pay this great sum. If it were for two or three thousand pounds, it could be borne, but for £15,000, besides the other engagements for His Majesty's service, it will utterly put me out of any possibility to do anything in those provisions which are so necessary for my lord duke's relief. I pray you let me know what I must trust.' The duke's expedition, thus starved of money, was a disaster; La Rochelle was reduced; and Cardinal Richelieu, imitating Pope Gregory XV, cannibalized its library.[13] But Charles I had got what he wanted. Having secured the pictures, he was glad to get out of the war. The agent who got him out was none other than that great preacher of peace, Peter Paul Rubens, who came to England as ambassador of Spain and was quickly booked to decorate the Banqueting Hall of Whitehall.

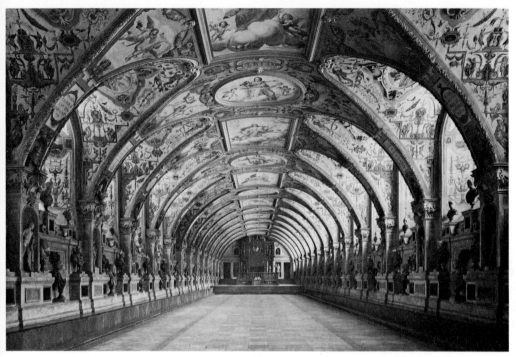

37 The Antiquarium of the Munich Residenz, built to house part of the great collection of the dukes of Bavaria.

But if peace came to England, in Europe the war went on, gathering momentum, and the plunder of the arts gathered momentum with it. In 1632 it was the turn of Munich. For by now the tide of war had turned: the Protestant powers, beaten to the wall in the 1620s, had been reinforced by a new and terrible ally from the north; and the same duke of Bavaria who had so light-heartedly presented to the pope the looted Palatine Library, was now to suffer an appropriate nemesis in his own capital.

For thirty-three years the Elector Maximilian I had been building up his collection, regardless of trouble and cost. He was the first duke of his house to break the spell of Italian taste, seeking out German and Flemish masters. Particularly he looked for Dürers. No trouble, no price was too great for him if a Dürer was in the market. He outbid even the Emperor Rudolf for Dürer's *Assumption of the Virgin*, and he

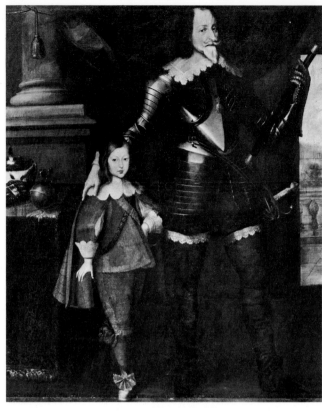

38 *The Elector Maximilian I of Bavaria, with his son.*

would repay the city of Nuremberg for having at last yielded up to him the *Four Apostles*, which Dürer had specially painted for it, by ordering his army to spare the lands of that obsequious city. By 1632 the Wittels-bach collection was the greatest collection in Germany after that of the emperor. But in May of that year, the work of a whole generation was undone. The Swedish army of Gustavus Adolphus captured Munich, and when it left, and the Elector returned to his capital, what a sight greeted him! His collection, his *Kunstkammer*, his picture-gallery, all were ruined. In vain he wrote letter after letter seeking to recover his lost Dürers, Holbeins, Cranachs. In the end he gave up. Though he would reign for another twenty years, he had not the heart to re-create his picture-gallery, whose treasures were now dispersed or destroyed, or decorating the upstart palaces of Sweden.[14]

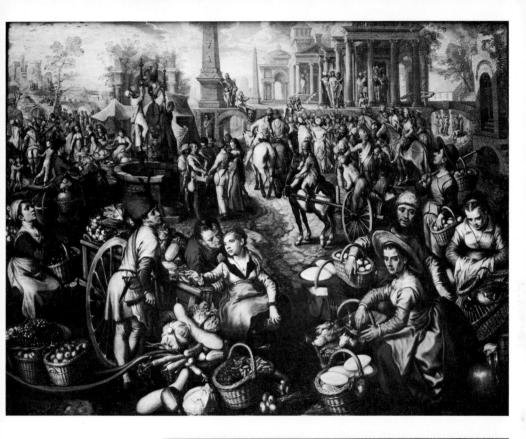

39, 40 *Joachim Bueckelaer's 'Market Scene' (above) and Cranach the Elder's 'The Payment' (right) were part of the Swedish booty at Munich. For some time Maximilian continued to include them in his inventories, hoping to recover them. But they are still in Stockholm.*

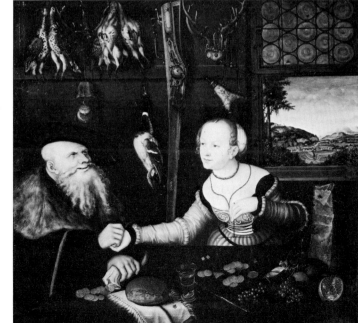

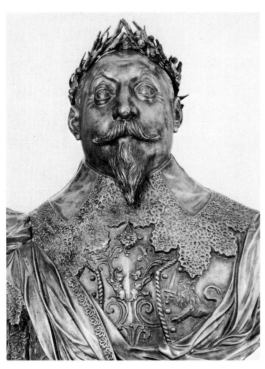

41 Gustavus Adolphus, king of Sweden (1611–32).

For now a new robber court had entered the market: a court which was collecting with the indiscriminate greed of a parvenu and the unashamed methods of a bandit. Gustavus Adolphus had entered Germany in 1630 as the champion of Protestantism, the avenger of Heidelberg. He bequeathed to his successors a brief robber-empire in the Baltic and an even briefer cultural centre in Stockholm. Wherever the Swedish armies went, they seized and sent back to Stockholm the artistic spoils of Europe: Russian icons from Riga and Pskov, altarpieces from Stargard and Braunsberg, pictures by Matthias Kräger from Würzburg, altarpieces by Grünewald from Mainz (which were lost at sea on the way to Sweden), libraries from Würzburg, Bremen, and the looted Jesuit and Capuchin churches of Olmütz. Gustavus' own great haul was at Munich. Six months later he was dead, and his throne was occupied by his daughter, the child who would become the most famous and most predatory of royal blue-stockings, 'the Hyperborean Minerva', Queen Christina.[15]

42–44 Some of the loot from Gustavus' campaigns in Germany. Right: a medieval gilt silver cross from Halle Cathedral. Below: an abbot's crozier from the monastery of Erbach. Below right: a head reliquary from Goslar.

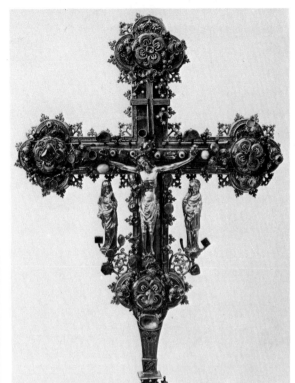

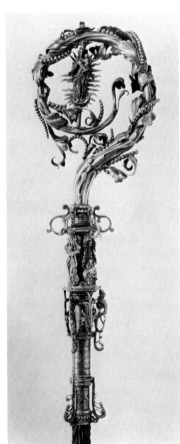

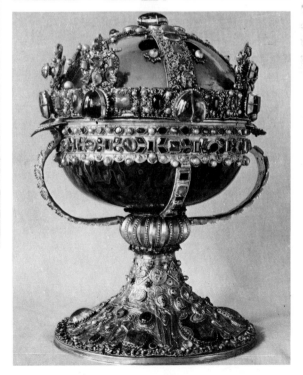

45 *Queen Christina's cultural appetite was for books as much as for works of art. This cover, of Laurentius Surius', 'De probatis sanctorum historiis' came from the library of a prince-bishop of Würzburg and bears his crest.*

 Queen Christina was a glutton for culture. She would summon to her court the greatest intellectual figures of Europe; and on the boat they would find themselves jostling with printers and book-binders, 'pipers, fiddlers and *chefs de cuisine*', all hastening northwards to the same destination. She would kill Descartes by forcing him to give her tutorials in philosophy at 5.00 a.m. on Swedish mornings. She bought libraries wholesale as they came on the market.[16] She had agents in London, The Hague, Rome, watching for bargains. German cities were laid under tribute and crate after crate of books, manuscripts, pictures and jewels was sent constantly northwards to the insatiable queen. And of course the fashion, once set, was quickly followed. Just as English aristocrats copied their king, so Swedish noblemen copied their queen: de la Gardies, Wrangels, Brahe, Skytte, Oxen-stjerna, Königsmarck filled their grotesque new palaces with their share of the loot.

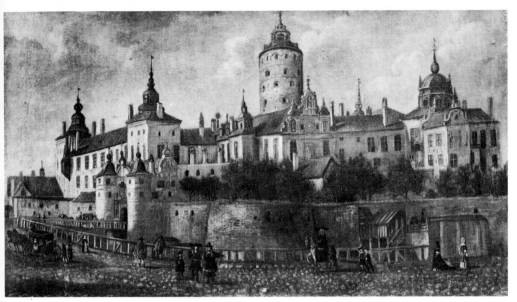

46, 47 *The Castle of Stockholm with, in the right foreground, the cage where the lion from the imperial menagerie of Prague was kept. Below: Queen Christina among her scholars. An imaginary conversation piece painted long after the queen's visit to Paris. Descartes stands in front of the queen.*

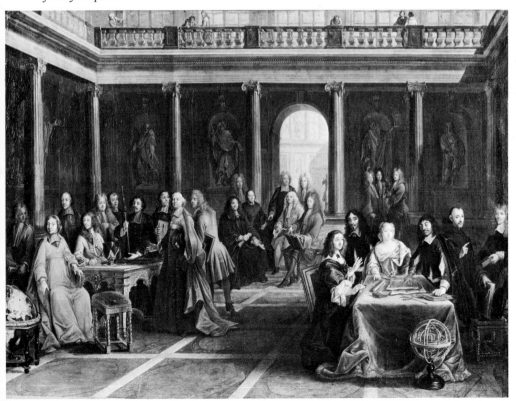

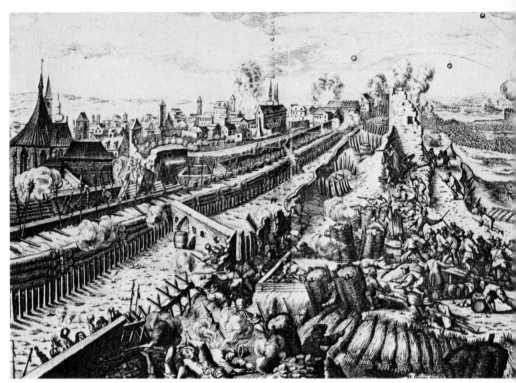

The greatest treasure of all, of course, was still the Emperor Rudolf's collection at Prague. In 1639 the Swedes occupied Prague; but on that occasion they missed their prey. The imperial chamberlain, Dionisio Miseroni, had removed it in time to a safe hiding-place. But nine years later the Swedish troops were again at the gates of Prague, and by now the queen was of age and determined not to miss the spoil. She was also determined to act quickly, for already the plenipotentiaries had assembled in Münster to conclude a general peace and if she did not strike now, she might be too late. So she ordered her generals – her cousin, Prince Charles Gustavus of Zweibrücken, afterwards her successor as Charles X, and Count Königsmarck – to lose no time. Prague must be taken; and this time the imperial treasures must not escape.[17]

The generals did their part. Just in time – just before the signing of the peace of Westphalia – Prague was captured and sacked. This time

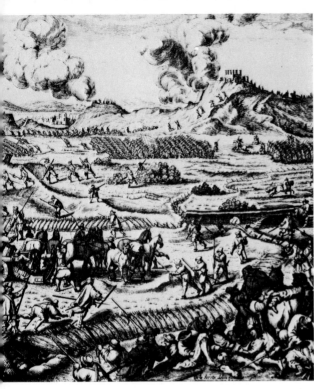

48 The storming of Prague by Swedish troops in 1648.

there was no opportunity for concealment, and the queen's commands were explicit. 'Take good care', she wrote, in a private postscript to her cousin, 'to send me the library and the works of art that are there: for you know that they are the only things for which I care.' So all – or almost all – that remained of Rudolf II's picture-gallery, all the statues and *objets d'art*, the whole imperial library, and even a live lion from the imperial menagerie, were seized and loaded on to five barges which then set off, sailing slowly down the Elbe towards the north. Many of them, of course, disappeared *en route*; but 570 of Rudolf's pictures arrived ultimately in Stockholm. So did a huge collection of books and manuscripts – which soon also began to leak out through the dishonest librarians of the voracious but incurious queen. When Christina came to the throne, there had been only one picture – and that Swedish – in the royal palace. Twenty years later, Stockholm was one of the artistic capitals of Europe. It was a capital stocked entirely with loot.[18]

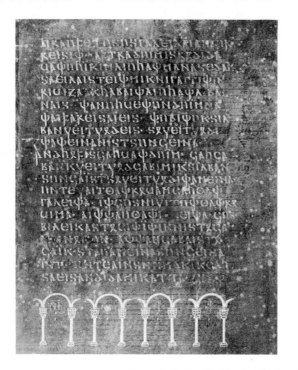

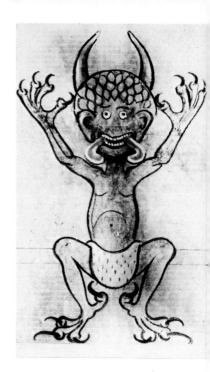

49–51 *Among the books seized by the Swedes at Prague was the 'Codex Argenteus' (above left), a unique Gothic sixth-century manuscript of the New Testament written in silver ink on purple vellum. Below: the silver book-cover made for the Codex by a Swedish artist in 1669. The devil (above right) is from another looted imperial manuscript, the thirteenth-century Bohemian 'Codex Gigas'.*

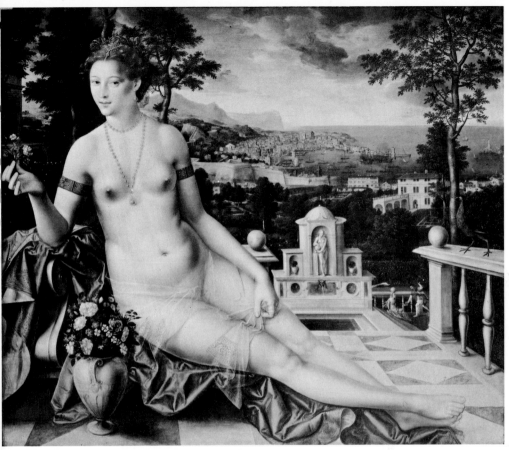

52 Jan Massys' 'Venus', looted by Königsmarck in 1648 and now in Stockholm.

A few years later, a further episode dispersed them still further. In 1654 the queen, who had sought so forcibly to drag the culture of Europe northwards to Stockholm, suddenly changed her mind. At the age of twenty-eight she decided to give up the effort and, instead, to follow culture to its natural centre in the south. She entered the Roman Church, abdicated her crown, shook from her feet the dull, Lutheran dust of her dreary country, and migrated to the more congenial climate of Rome. There, for the next thirty-five years, this tyrannical spinster would both eat her royal cake and have it, gossiping with worldly

47

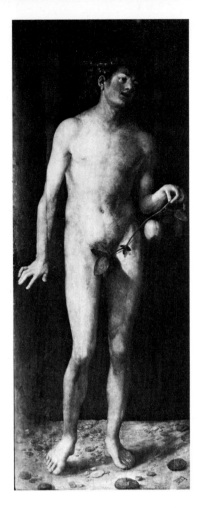

53–55 Some of the pictures from Prague were disposed of during Christina's lifetime by being sold or given away. Dürer's 'Adam and Eve' (above) were presented by her to Philip IV of Spain. The letter (right) is from the queen to an agent instructing him to send them to her factor in Hamburg.

56 In 1654 Queen Christina abdicated, became a Catholic, and a year or so later settled in Rome. The duke of Parma placed the Farnese Palace at her disposal, and these new decorations were designed for her by the architect Carlo Rainaldi.

cardinals, enjoying royal precedence without any of the tedious respon‑sibilities of a crown. With her she took most of her spoils; and if she was obliged to leave some of them in Sweden, she soon refilled the gaps. Her way south lay through Flanders. There she stopped for a year, to see the great gallery of the Archduke Leopold William in Brussels and haunt the sale‑rooms of Antwerp. To pay her huge travelling expenses, she sold many of her treasures, but ended by buying others. Even in Rome she reverted to her old methods: she pillaged the Farnese palace, which its owner had kindly but imprudently put at her disposal.

49

57 Inventory of Christina's furniture destined for Rome.

58 Page from a Carolingian manuscript taken by Christina to Rome, and now in the Vatican Library.

(Cardinal Mazarin was wiser: when she visited Paris, he excluded her firmly from his gallery.) When she died, in 1689, she left all her property to 'that divine man', as she called him, Cardinal Azzolini; after which her collections had a varied history of bequest and sale until the royal library of Stockholm, like the electoral library of Heidelberg, sank into the Vatican Library, and the royal picture gallery was dispersed and now lies, to a large extent, embalmed in a series of aristocratic English collections.[19]

So, through the wilfulness of one woman, the imperial treasures of Rudolf II were scattered over the world. Well might Alfons Lhotsky, the historian of the Habsburg collection, describe the capture of Prague as 'an infamous robbery'. Only the catastrophe of the Mantua collection, he writes, can be compared with it: those two disasters, of 1630 and 1649, 'are unquestionably among the most grievous losses in European cultural history'.

59 Paolo Veronese's 'Hermes, Herse and Aglauros', one of Christina's acquisitions from Prague, went with her to Rome and then passed by various sales to an English private collection.

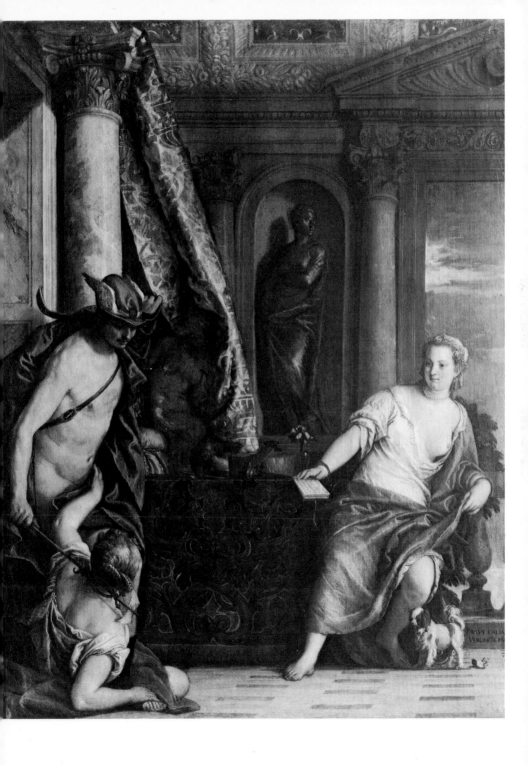

60 *Right: Titian's portrait of Baldassare Castiglione was bought by Christina in Genoa in 1667 (it was then catalogued as by Giulio Romano). After her death it passed through several Italian and French families, and in 1800 was bought in London by the earl of Mansfield.*

61 *Below: 'Venus, Cupid and a Lute Player' by Titian. This was another of the paintings seized by the Swedes at Prague in 1648. It, too, eventually came to England and was bought in 1789 by Viscount Fitzwilliam.*

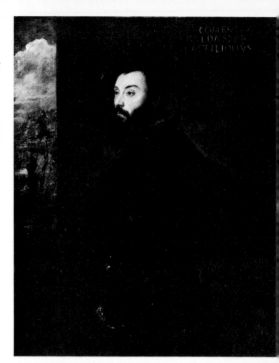

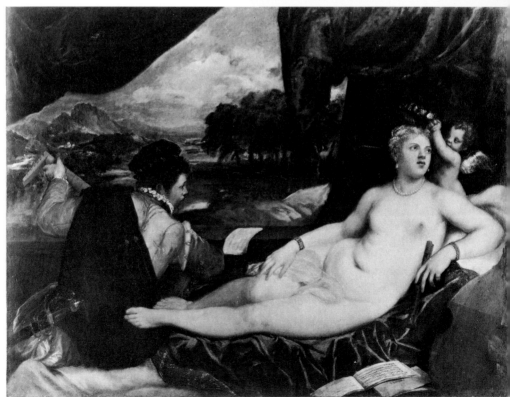

For meanwhile the collection of Mantua had also gone the same way as the collection of Prague. Within a year of the ruin of Rudolf II's *Kunstkammer* occurred the catastrophe of the Stuart gallery; that marvellous personal gallery built up with such undeviating zeal and exquisite taste by the most unfortunate of English kings; that gallery to whose formation politics had been sacrificed and which was now, in turn, sacrificed to political and ideological revolution. For Charles I's collection was not merely a victim of war or plunder. It was not merely, like the Mantuan collection (now included in it), liquidated to pay economic debts. It was the victim also of an iconoclastic movement: a movement that was moral and social as well as political and which went back to the Reformation and beyond.

To the iconoclast of the sixteenth century – to those zealots of reform who hewed down the organs, smashed the stained-glass windows and decapitated the statues of northern Europe – these works of art were the visible symbols of a hated social system. They were fetters whereby the old Church had enslaved the minds of simple men, 'dead images' to whose costly maintenance 'the lively images of Christ' were being daily sacrificed. In the seventeenth century the lavish princely courts, having taken over so many of the functions of the established Church, had also inherited its enemies. Princes, it now seemed, had separated themselves from their subjects, elevated themselves beyond their reach, withdrawn into a narrow circle of connoisseurs. So, at the crisis of the English Revolution, the gallery of Whitehall would pay the price. The English Puritans had already hewn down the great cross of Cheapside in London. They had already desecrated the exquisite chapel of Henry VII at Westminster and decapitated the effigies in the English parish churches. They had destroyed the queen's chapel and thrown a painting by Rubens into the Thames. They had voted to sell the English cathedrals for scrap. Finally, when Charles I had been decapitated too, they turned to his incomparable collection of pictures and, since their needs were pressing, did not destroy them, but put them up for sale.

Some indeed were given away privately, in settlement of old debts or claims, and some were explicitly reserved, as Oliver Cromwell

appropriately reserved Mantegna's *Triumphs of Julius Caesar* to decorate his apartments at Hampton Court. But in general, the best of them were sold. And what a sale it was! The kings of Europe, whom Charles I had so often undercut or outbid, now saw their opportunity. While still uttering scandalized protests at the act of regicide, they sent their agents furtively to London. In the shocked words of Clarendon, instead of making common cause against the enemies of royalty, the barbarous assassins of an anointed colleague and kinsman, 'they made haste and sent over, that they might get shares in the spoils of a murdered monarch'.

62, 63 Two of Charles I's Titians which were sold after his execution to agents of Philip IV of Spain: the 'Speech of the Marques del Vasto' and (right) the Emperor Charles V.

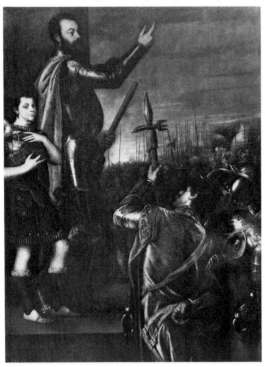 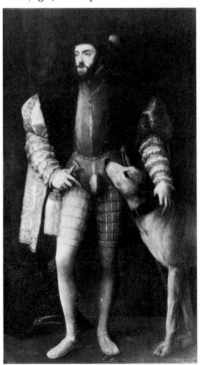

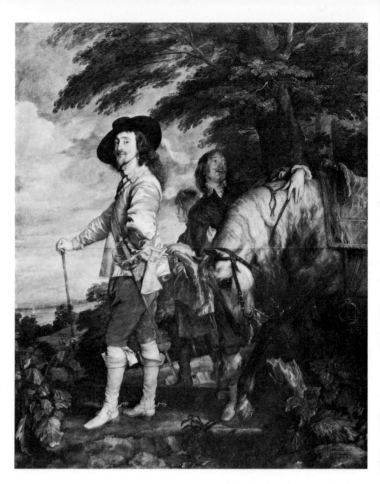

64 *Van Dyck's portrait of Charles I, auctioned under the Commonwealth, entered the French royal collection via Madame du Barry.*

So there we find them again, all the old predators, each hidden behind his secret agent, as Charles I himself had hidden behind Daniel Nys. The Spanish ambassador, through a cut-out, recovered for Philip IV the Titians which Charles had collected in Spain. The ambassador pretended to be acting for the royal favourite, Don Luis de Haro; and Don Luis in his turn, kept up the pretence: on receiving the pictures, he declared them too fine for a subject and obsequiously laid them at his master's feet. Cardinal Mazarin, though himself in trouble from the revolutionary *Frondes*, nevertheless contrived, through the French ambassador, to secure his share. Queen Christina, unsated by the spoils

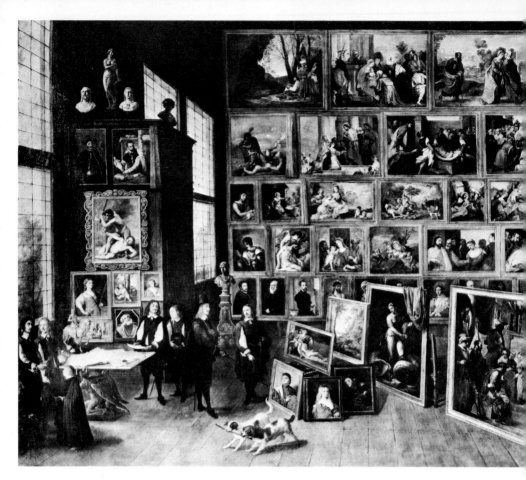

of Prague, sent her agent Michiel le Blon to bid for the jewels. The Habsburg governor of Flanders, the Archduke Leopold William, who so loved to be painted by Teniers, surveying his own splendid collection, seized his chance. From his vantage-post in Brussels, he had already fished in the remains of two great English collections, wrecked on the rocks of revolution: those of the duke of Buckingham and the earl of Arundel. Now he secured an even richer prize. The fifth of the great purchasers, somewhat incongruous among these kings and statesmen, was a Cologne banker, now resident in Paris, Everhard Jabach, who bought both for Mazarin and for himself. Jabach, we are told, returned

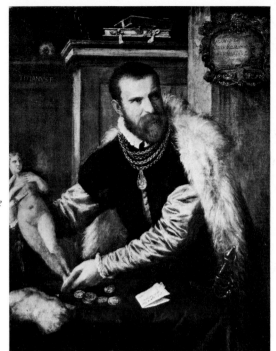

65–67 *One of the purchasers of Charles I's pictures was the Archduke Leopold William, governor of the Spanish Netherlands. He is here portrayed, surveying his collection, by Teniers the Younger. Titian's portrait of Jacopo da Strada (right) and Giorgione's 'Three Philosophers' (below) are recognizable in the upper rows. Both these paintings returned with the archduke to Vienna in 1656 and are now in the Kunsthistorisches Museum.*

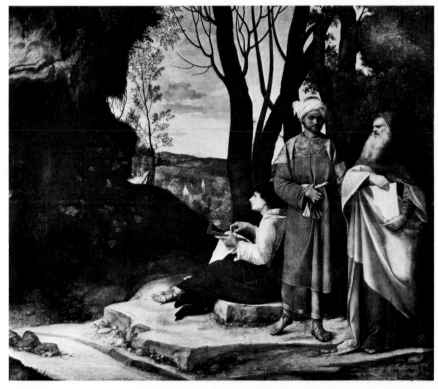

to Paris at the head of a convoy of wagons, 'loaded with artistic con‑
quests, like a Roman victor at the head of a triumphal procession'. The
kings of whose purchases Clarendon wrote with such withering scorn
were at least a little more delicate than that. Indeed, Clarendon himself,
who was at that time ambassador of the exiled Charles II to the court of
Spain, was discreetly ordered away from Madrid lest he should see,
coming into the city, the dusty train of eighteen mules which had
carried from Coruña, the spoils of the murdered monarch.[20]

But if the sale of Charles I's pictures was the most spectacular, it was also
the last of those great acts of artistic plunder which accompanied the
Thirty Years' War. The mid‑seventeenth century, here as in so much
else, was a watershed in history: a period of separation, of disintegration.
If politics thereafter were separated from religion, art also was detached
from the ideological pattern in which, hitherto, it had been set; and
because it was so detached – because it no longer seemed part of the
mana, the prestige, of a particular system of government or belief –
iconoclasm too, which is the moral or social hatred of art, lost its
purpose. Ideological wars now went out of fashion, and with them went
some at least of the ferocity of war. In the limited wars of the next
century, rules and conventions were observed. Princes and generals
no longer looted each other's palaces or deliberately stole each other's
property.

Besides, were these treasures really their personal property? In 1649
the people of England had undoubtedly been shocked by the execution
of Charles I and the destruction of monarchy, but they do not seem to
have felt a national loss when his pictures were sold. Only the people of
Mantua seem to have regarded the loss of the ducal pictures as an insult
to themselves, a national insult. But in the following century the views
of the people of Mantua gradually became general. The great royal
collections might remain legally private but in fact they became
national collections. The collections of Richelieu, Mazarin, Jabach – all
concentrated in the hands of Louis XIV – became the nucleus of the
Louvre; that of Philip IV was transformed into the Prado; that of the

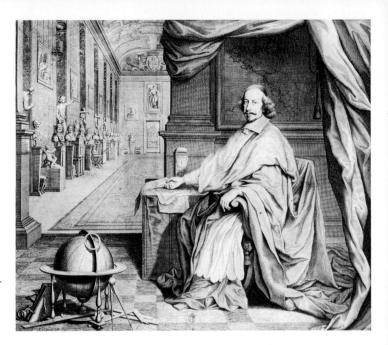

68 *Cardinal Mazarin in his gallery. Mazarin bought several of Charles I's pictures and from him they passed to Louis XIV.*

Archduke Leopold William, who returned to Austria in 1656, fed the Kunsthistorisches Museum in Vienna. So it is in these three national museums that we will find, today, the Titians which once belonged to Charles I. Appropriately, Queen Christina, that eccentric anachron, ism, was the last monarch to carry off, as her personal property, a national collection . . . and even here the Swedish Government made some faint, unavailing remonstrances, seeking to distinguish between private and public possessions.

In the last three centuries the artistic treasures of the world have indeed changed hands, on a huge scale – how else would the museums of America be stocked? – but it has been by private sale. Though the princes may have gone, the great European princely collections have remained – with few exceptions – intact. They have been, *de facto* or *de jure*, nationalized. The plunderers, it is true, have not ceased. Napoleon and Hitler did their best. But, in the long run, they did not succeed. Unlike Pope Gregory XV and Queen Christina, they did not get away with their spoils.

NOTES

1 Albert Speer, *Erinnerungen* (Berlin, 1969; English tr. London, 1970); Cecil Gould, *Trophy of Conquest, the Musée Napoléon and the Creation of the Louvre* (London, 1965).

2 It is the subject of an excellent work, to which I am indebted, J. von Schlosser, *Kunst und Wunderkammern der Spätrenaissance* (Leipzig, 1908).

3 I take the phrase from Mr F.H. Taylor's book, *The Taste of Angels* (London, 1948).

4 For Philip II's activity as a patron, see the pioneer essay of Carl Justi, 'Philipp II als Kunstfreund' in his *Miszellaneen aus drei Jahrhunderten Spanischen Kunstlebens* (Berlin, 1908); also Pedro Beroqui, *Tiziano en el Prado* (Madrid, 1927). According to Beroqui, Philip II *'es mas acreedor que ningún otro gubernante español, antiguo ni moderno, a la gratitud de los amantes de las bellas artes'* (p. 149). For the Familist heresy of Benito Arias Montano, Abraham Ortelius and Christopher Plantin, see B. Rekers, *Benito Arias Montano 1527–1598* (Amsterdam, 1962).

5 For the Habsburg collections in Austria and Bohemia see especially Alfons Lhotsky, *Die Geschichte der Sammlungen* (Vienna, 1941–45).

6 Franz von Reber, 'Zur Geschichte des Bayrischen Gemäldeschatzes', in *Katalog der älteren Pinakothek* (Munich, 1925). See also, for the Munich collections, M.G. Zimmermann, *Die Bildende Kunst am Hof Herzog Albrechts V von Bayern* (Strasbourg, Studien zur deutschen Kunstgeschichte,

1895); Franz von Reber, *Kurfürst Maximilian I von Bayern als Gemäldesammler* (Munich, 1892).

7 For Antwerp as artmarket see the two studies of Jan Denucé, *Inventare und Kunstsammlungen zu Antwerpen in den 16ten und 17ten Jahrhunderten* (Antwerp, 1932), and *Kunstausfuhr Antwerpens im 17ten Jahrhundert, die Firma Forchoudt* (Antwerp, 1931). Also J.A. Goris, *Etudes sur les colonies marchandes méridionales . . . à Anvers de 1488 à 1567* (Université de Louvain, recueil des travaux, 2e série, fasc. 4. Louvain, 1925), pp. 280ff.

8 For this episode see Josef Svátek, *Die Rudolphinische Kunstkammer in Prag* (Vienna, 1879) pp. 225ff.; Alfons Lhotsky, *op. cit.*

9 The best account of the Palatine Library known to me is in H. Stevenson, sen., *Codices MSS Palatini Graeci Bibliothecae Vaticanae* (Rome, 1885).

10 For the work of Baronius see H. Stevenson, sen., *Codices Palatini Latini Bibliothecae Vaticanae* (Rome, 1886), pp. cxvii–cxix.

11 For Allatius see *Dizionario Biografico degli Italiani*, II (Rome, 1960), *s.v.* 'Allacci, Leone'.

12 For the history of the Mantuan collection and its sale see Alessandro Luzio, *La Galleria dei Gonzaga* (Milan, 1913).

13 See Edmond Bonnaffée, *Recherches sur les collections des Richelieu* (Paris, 1883).

14 Franz von Reber, *Kurfürst Maximilian I von Bayern* (see Note 6).

15 For the Swedish collections before Queen Christina see Olof Granberg, *Svenska Konstsamlingarnas Historia* (Stockholm, 1929), vol. I.

16 For Queen Christina's library see Friedrich Blum, *Iter Italicum* (Halle, 1830), vol. III, pp. 55–64; B. Dudik, *Iter Romanum* (Vienna, 1855), vol. I, pp. 123–80; H. Stevenson sen., *Codices MSS Graeci Reginae Svecorum et Pii P.P. II Bibliothecae Vaticanae* (Rome, 1888), pp. 123, 167.; Sten G. Lindberg, 'Queen Christina of Sweden', *Documents and Studies*, ed. Magnus von Platen (Stockholm 1966), pp. 199–225.

17 That Queen Christina ordered the attack of Prague in order to secure the imperial collection was stated by Svátek, *op. cit.* in 1879. The point cannot be proved; but it seems the only reasonable explanation, and has been adopted by the two modern historians of the collection, Alfons Lhotsky (*op. cit.*) and Jaromir Neumann (*La Galerie de Tableaux du Château de Prague*). As Neumann writes (p. 25), *'les chercheurs actuels acceptent cette hypothèse, non confirmée jusqu'à présent, comme assez vraisemblable'*. For Dr Neumann's work, which is unprinted, I am indebted to Professor Peter Murray of Birkbeck College, London.

18 For Queen Christina's picture gallery and its later history, see Olof Granberg, *Drottning Kristinas Tavelgalleri . . .* (Stockholm, 1896). (Forty-five copies of a French translation of this work were published at Stockholm in 1897, as *La Galerie de Tableaux de la Reine Christine de Suède ayant appartenu à l'Empereur Rodolphe II, plus tard aux Ducs d'Orléans*.)

19 The earliest and best account of the sale of Queen Christina's pictures is the first-hand account by William Buchanan, *Memoirs of Painting* (London, 1824), vol. I. See also Granberg, *op. cit.*, and Ellis Waterhouse, 'Queen Christina's pictures in England', *Analecta Reginensia*, I (Stockholm, 1966), pp. 372–75.

20 The standard work on the sale of Charles I's pictures is Sir Claude Phillips, *The Picture Gallery of Charles I* (London, 1895). See also *Abraham van der Doort's Catalogue of the Collections of Charles I*, ed. Oliver Millar (Walpole Society, vol. XXXVII, 1958–60). Mr Millar, to whom I am indebted for much help on this subject, is also editing, for the same society, in 1971, the inventories drawn up by the Commonwealth agents as a preliminary to the sale of all the royal goods. On some details of the Commonwealth sale see W. L. F. Nuttall, 'King Charles I's Pictures and the Commonwealth Sale', *Apollo*, Oct. 1965.

The quotation from Clarendon is from his *History of the Rebellion* (ed. W. D. Macray, 1888), IV, 497–9. For Jabach see F. Grossman, 'Holbein, Flemish Painters and Everhard Jabach', *Burlington Magazine*, Jan. 1951.

LIST AND SOURCES OF ILLUSTRATIONS

1 *Saint George*, c. 1590. Gold, silver gilt, and precious stones. Munich, Schatzkammer der Residenz. *Bayerische Verwaltung der Staatlichen Schlösser, Gärten und Seen*

2 Frans Francken II: *Kunstkammer*, 1636. Panel. *Frankfurt, Historisches Museum*

3 Hendrik Staben: *Albert and Isabella visiting Rubens' Studio*, early 17th century. Panel. Brussels, Musées Royaux des Beaux-Arts. *ACL*

4 Anton Mozart: *Delivery of a 'Kunstschrank' to Duke Philip II of Pomerania*, 1617. Panel. Berlin, Kunstgewerbemuseum

5 *Schloss Ambras*, from Matthæum Merian, *Topographia Provinciarum Austriacaru* . . . (Frankfurt 1649). Engraving. London, British Museum. *R.B. Fleming*

6 Aegidius Sadeler: *Wenceslas Hall in the Hradčany Palace, Prague*, 1607. Copper engraving (detail). London, British Museum. *John Freeman*

7 *Banquet at the Court of Emperor Rudolf II in Prague*. Vienna, Österreichische Nationalbibliothek, MS. Cod. 7906, folio 16v–17

8 Rubens: *Archduke Albert*, c. 1609. Panel. *Vienna, Kunsthistorisches Museum*

9 Rubens: *Archduchess Isabella*, c. 1609. Panel. *Vienna, Kunsthistorisches Museum*

10 Adriaen de Vries: *Emperor Rudolf II*, c. 1600. Bronze. *Vienna, Kunsthistorisches Museum*

11 Gerhard Emmoser: Celestial Globe on the back of Pegasus, 1579. Bronze silvered, silver, and silvergilt. *New York, Metropolitan Museum of Art, gift of J. Pierpont Morgan, 1917*

12 Credence Vessel, late 16th century. Silver and fossilized sharks' teeth. *Vienna, Kunsthistorisches Museum*

13 'Kunstschrank' of Emperor Rudolf II. *Vienna, Kunsthistorisches Museum*

14 Giuseppe Arcimboldi: *The Gardener*. Panel. Skokloster, Baron Rutger von Essen. *Stockholm, Nationalmuseum*

15 Pieter Brueghel I: *Dulle Griet*, 1562/64. Panel (detail). Antwerp, Museum Mayer van den Bergh. *ACL*

16 *Ilioneus*, Roman copy after a Greek original of the 4th century BC. Marble. *Munich, Glyptothek*

17 Isaac Oliver: *Frederick V, Elector Palatine*, c. 1613. Miniature. *Windsor, Royal Library*. Reproduced by gracious permission of Her Majesty the Queen. Copyright reserved

18 Frans Francken II: *Private Art Gallery*, after 1616. Panel. Munich, Schloss Schleissheim. *Direktion der Bayerischen Staatsgemäldesammlungen*

19 Page from the Eclogues with initial showing figures of Tityrus and Meliboeus, from Virgil, *Opere*, 1474. *Biblioteca Apostolica Vaticana*, MS. Palatino Latino 1632, folio 3

20 *David between Wisdom and Prophecy*, from a Psalter, 12th–13th centuries. *Biblioteca Apostolica Vaticana*, MS. Palatino Greco 381, folio 2

21 *St John*, from the *Lorsch Gospels*. Carolingian Palace School, c. 800. *Biblioteca Apostolica Vaticana*, MS. Palatino Latino 50, folio 67v

22 Ivory cover of the *Lorsch Gospels*, c. 800. *Biblioteca Apostolica Vaticana*